Handmade
Paper Pierced Cards

Patricia Wing

SEARCH PRESS

First published in Great Britain 2008

Search Press Limited
Wellwood, North Farm Road,
Tunbridge Wells, Kent TN2 3DR

Text copyright © Patricia Wing, 2008

Photographs by Roddy Paine Photographic Studios

Photographs and design copyright © Search Press Ltd. 2008

ISBN-13: 978-1-84448-247-4

The Publishers and author can accept no responsibility for any consequences arising from the information, advice or instructions given in this publication.

Readers are permitted to reproduce any of the items in this book for their personal use, or for the purposes of selling for charity, free of charge and without the prior permission of the Publishers. Any use of the items for commercial purposes is not permitted without the prior permission of the Publishers.

Suppliers

If you have difficulty in obtaining any of the materials and equipment mentioned in this book, then please visit the Search Press website for details of suppliers:
www.searchpress.com

Publisher's note

All the step-by-step photographs in this book feature Patricia Wing's assistant, Ruth Venables, demonstrating how to make paper pierced greetings cards. No models have been used.

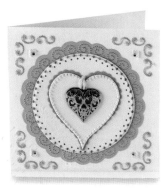

Dedication

To Ruth Venables, a lovely young lady who once again showed total commitment in the planning stages and studio sessions which helped bring this book into being.

A special remembrance of Gladys Bryce who introduced me to her exquisite quilling.

The Lord is the stronghold of my life.
Psalm 27

Also to my dear family: husband Tony, our son Andrew, daughter Louise and fast-growing granddaughters Shannon and Tilly Rose.

Acknowledgements

Many thanks to Roz Dace for commissioning this, my second book on cardmaking. Also I am very grateful for all the hard work Sophie, Juan and Ellie put in – you have made the book stunning. Thanks also to Roddy and Gavin at Roddy Paine Photographic Studios, and to:

Personal Impressions for embossed mounts and Pergamano parchment papers,
Creative Stamping for rubber stamps,
Williams for Anna Griffin punches and stencils,
Royal Langnickel Brush MT-G for rub-on transfers,
Andrew Street at Kars for Avec stencils,
Graham Hansford at Bramwells & Craft Too for EK Success punch and Ornare stencils,
Fred Aldous for quilling papers,
Crafty Things for metal embellishments,
Woodware for daisy punches,
Impex for beads,
Croft Petals for pressed flowers and
Daler Rowney for light boxes.

Cover
Sweet Lavender
See pages 14–17.

Page 1
Embroidered Fan
The fan on this card is made from paper with a scalloped edge, with bugle and seed beads for the spokes. It is decorated with gold embroidery and surrounded by an embossed frame and corners. Gems, a leaf bead and a teardrop-shaped jewel complete the picture.

Contents

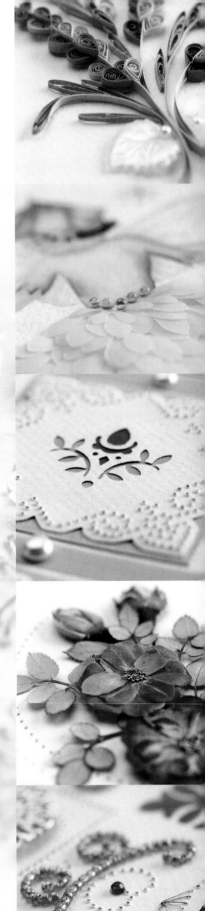

Introduction

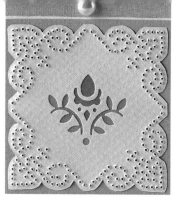

In this book you will find some of my favourite papercraft techniques, with paper piercing used to enhance the main design. I hope you will feel that all the different techniques work well together.

I have included the historic craft of quilling. This is quite a simple art to master, but I have seen the most exquisite designs exhibited. The Sweet Lavender card on page 14 has a quilled flower design with a pierced border, and it is finished off with embellishments.

As a child I remember having fun with transfers, so you can imagine my delight when a huge array of fantastic designs became available to cardmakers. The rub-on transfers I have used will give your cards a really professional finish.

Most cardmakers have probably used punches before. In the Rosebuds projects on page 26, I show how you can achieve beautiful results using only one punch combined with paper piercing techniques.

Another historic craft included in this book is that of using pressed flowers. I have always enjoyed pressing flowers and of course this has been a delightful hobby for many generations, with flowers and leaves used to decorate bookmarks, cards, boxes and scrapbooks over the years.

The Embroidered Creation card on page 40 features paper piercing, embroidery on paper, sewing on beads and punching, so you can see how the various techniques can be combined in one design.

Pat Wing

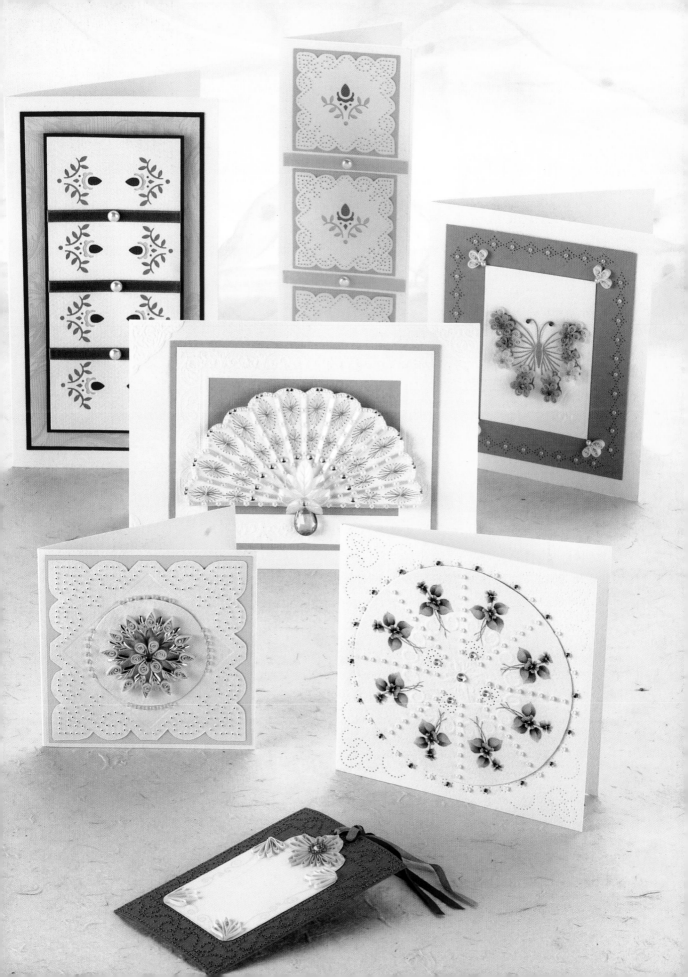

Materials

Many of the materials you will need are general craft tools that you may have already. In addition, you will need some specialist equipment, some sticking supplies and papers and embellishments to make the cards shown in this book.

Templates and stencils

Templates for paper piercing provide professionally designed patterns for you to use in your cardmaking. They are often metal with a painted finish, while embossing stencils are usually made from unpainted brass. Many companies now produce multipurpose stencils that are ideal for both piercing and embossing. This gives plenty of scope for introducing new techniques into your cardmaking.

Paper piercing templates, embossing stencils and multipurpose stencils for both piercing and embossing.

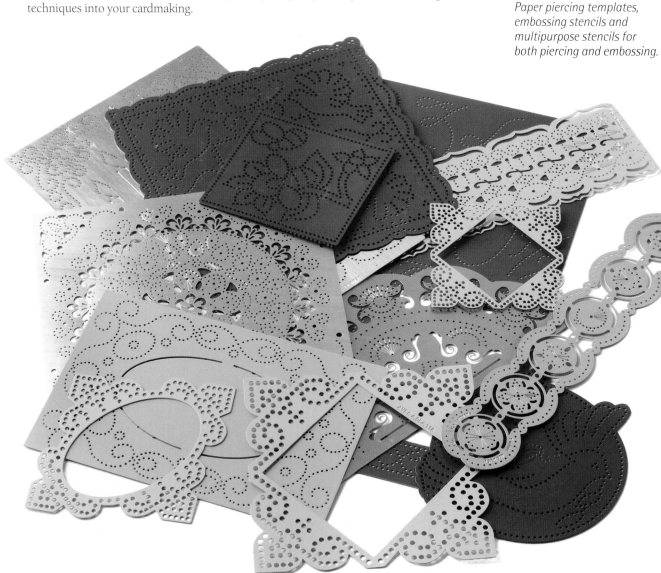

Tools

The light box I have used for paper embossing is battery operated, making it perfect for cardmaking on holiday or anywhere without a power supply. Another advantage is its low-heat light bulb.

Other basic tools are a **craft knife**, **cutting mat** and **metal ruler** for measuring and cutting card and paper. A cutting mat with a grid is useful for measuring borders (see page 10).

A **pencil** and **eraser** are used for marking out cards and designs.

Fine scissors are needed for cutting out delicate shapes and for cutting embroidery threads. **Scalloped scissors** are used for creating a decorative edge.

There is a superb range of craft **punches** available which will complement your other craft supplies.

A **pricking tool** and **pricking mat** are used for the paper piercing techniques.

Large, medium and small **embossing tools** are needed for embossing designs.

You will need **needles** for embroidering on paper. Size 12 quilting needles are best for sewing beads on to cards.

A **quilling tool** is used for rolling quilling papers into coils.

Tweezers are used for placing delicate items such as quilling coils on your designs.

A **rubber stamp** has been used to create the design for the gift tag shown on page 18.

Cocktail sticks are useful for placing gems and beads.

Rub-on transfers come with a **stick** like a lolly stick to help you rub the design on to the card or paper.

A battery-operated light box.

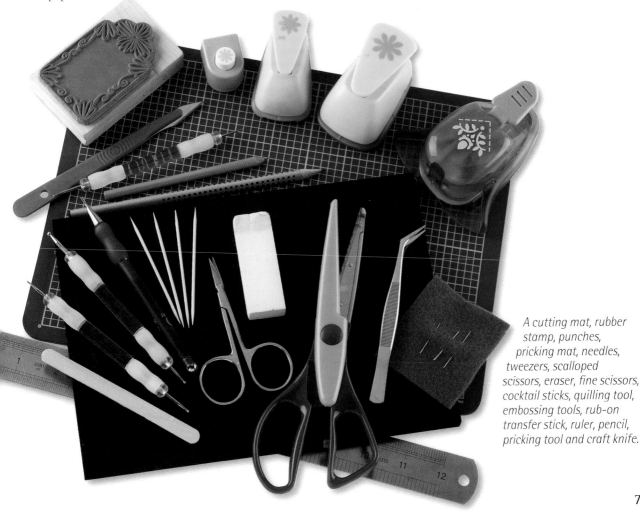

A cutting mat, rubber stamp, punches, pricking mat, needles, tweezers, scalloped scissors, eraser, fine scissors, cocktail sticks, quilling tool, embossing tools, rub-on transfer stick, ruler, pencil, pricking tool and craft knife.

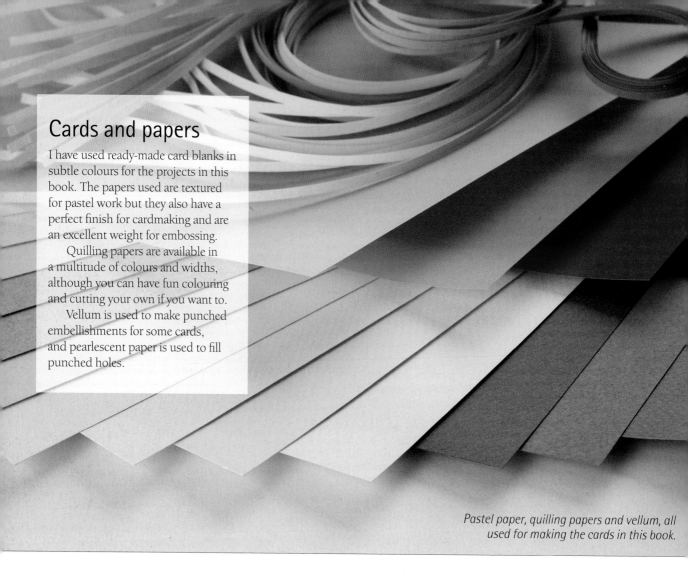

Cards and papers

I have used ready-made card blanks in subtle colours for the projects in this book. The papers used are textured for pastel work but they also have a perfect finish for cardmaking and are an excellent weight for embossing.

Quilling papers are available in a multitude of colours and widths, although you can have fun colouring and cutting your own if you want to.

Vellum is used to make punched embellishments for some cards, and pearlescent paper is used to fill punched holes.

Pastel paper, quilling papers and vellum, all used for making the cards in this book.

Sticky things

A fine-nozzled PVA glue dispenser is essential for sticking on gems and beads as it allows for precise positioning of tiny amounts of glue. It is also ideal for quilling. Choose a good quality PVA glue for your dispenser and your gems will stick quickly and firmly.

3D foam pads are available in different thicknesses starting with 1mm. They are very useful for adding depth to your work.

For large areas, double-sided tape is better than glue as it does not wrinkle the paper.

Masking tape is a must for attaching stencils to your work as it can be removed easily and does not leave marks on your card.

Embellishments

Embellishments can add that extra special something to your cards. They can also be an integral part of the design, as shown in the card at the bottom of page 19, in which quilling has been added to a metal embellishment.

Gems, beads and pearls can be added to your cards for a beautiful finish.

Rub-on transfers can be the main feature of a card, as in the Fairy Princess card on page 20. Adding little rub-on flowers to embossed cards also works well.

Gold thread is used to embroider the pierced designs in the cards on pages 40–47, and silk ribbon is used to decorate cards and bookmarks.

A decorative bouquet of lilies is used with a brass embellishment for the Wedding Card shown on page 47. A teardrop-shaped craft jewel is used for the Embroidered Fan card on the same page. Pearl-coloured plastic leaf beads make subtle decorations for many cards.

Pressed flowers make beautiful embellishments and are best teamed up with natural colours. Tiny accent beads are very effective when stuck to the centres of pressed flowers.

Punched shapes can make a beautiful addition to your cards, especially in vellum. For the Fairy Princess card, punched flowers have been cut up to form a flowery skirt for the fairy.

Ready-embossed frames can be bought to surround your designs, or you can make your own.

Rub-on transfers.

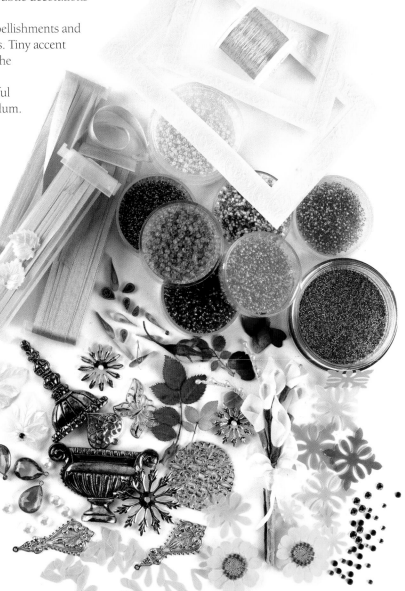

Embossed frames, gold thread, beads, bouquet of lilies, punched shapes, gems, beaded flowers, metal embellishments, craft jewels, plastic leaf beads, pressed flowers and silk ribbons.

Techniques

Basic techniques such as folding your own cards and making a border are useful in all cardmaking. Paper piercing, embossing and gluing on gems are simple techniques to learn and can be used to make beautiful cards.

Tip

It is vital to have a sharp blade in your craft knife and a smooth-edged metal ruler to achieve accurate results.

Card folding

You may want to cut and fold your own cards. It is important to find the centre of the card accurately and to make a nice sharp crease

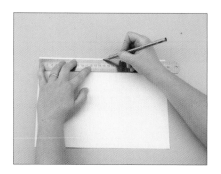

1 Use a ruler and pencil to mark the centre of the card at the top and bottom.

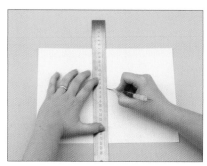

2 Line up the ruler with the pencil marks and score down its length with a small embossing tool.

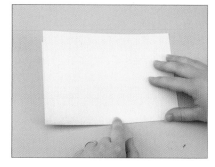

3 Fold along the scored line, smoothing it with your finger to make a sharp crease.

Making a border

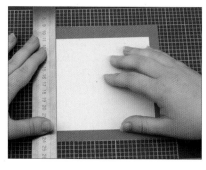

1 Mount the cream card in the centre of the purple card using double-sided tape. Line up the edge of the cream card with a line on your cutting mat, using your ruler to help you.

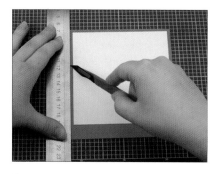

2 Use the lines on the cutting mat as a guide to help you to trim the purple card, leaving a narrow border around the cream card.

The cream card with its purple border.

Piercing

When you pierce paper through a template, you can achieve a raised or a smooth effect depending on whether you prick from the back or the front of the paper. Pricking from the back achieves a raised effect.

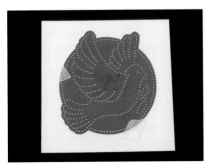

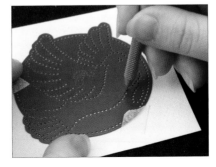

Tip
Always press the masking tape firmly in place to prevent the template from moving.

1 Use masking tape to attach the pricking template to the front of the card. Place the card on the pricking mat.

2 Pierce the pattern with the pricking tool.

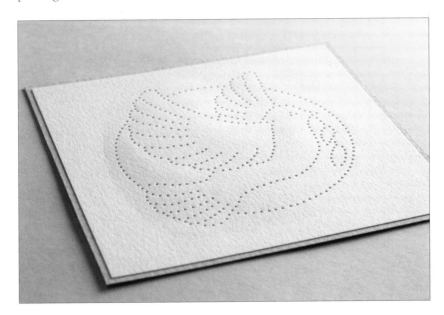

The finished design, pricked from the front of the paper.

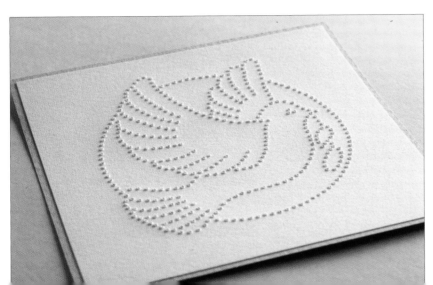

The same design pricked from the back of the paper to produce a raised effect.

Embossing with a light box

Embossing is always done from the back of the card. The embossing tool pushes the card into the pattern of the embossing stencil, to produce a raised effect on the front of the card.

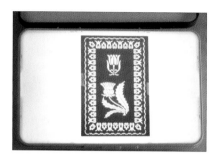 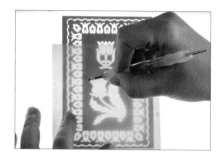

1 Use masking tape to fix the embossing stencil to the centre of the light box and switch on the light.

2 Tape the card over the stencil and use the embossing tool to emboss the lit areas of the design.

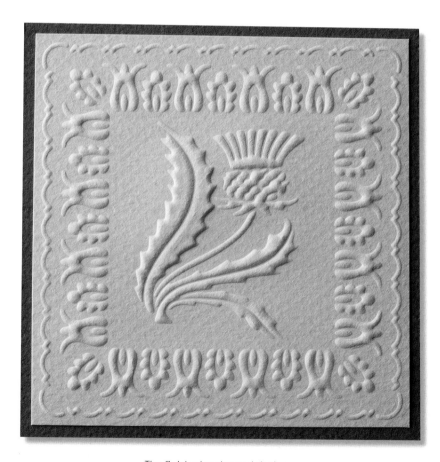

The finished embossed design.

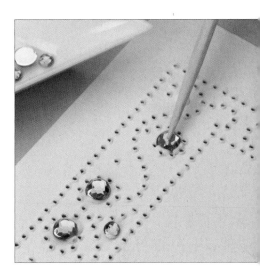

Gluing on gems

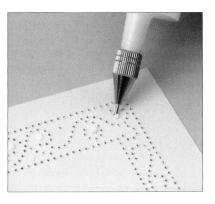

1 Place dots of PVA glue where you want the gems to go.

2 Put a tiny dot of PVA glue on the end of a cocktail stick and use it to pick up and place a gem.

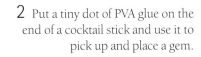

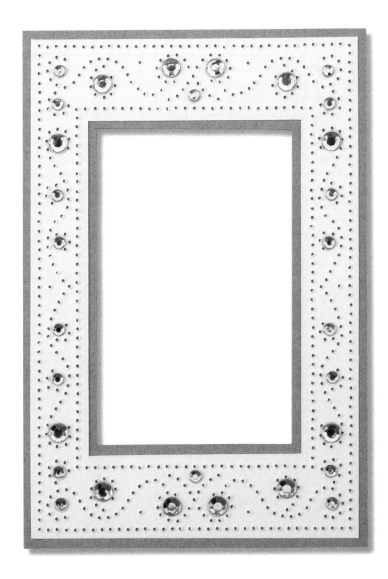

The pricked piece, decorated with gems.

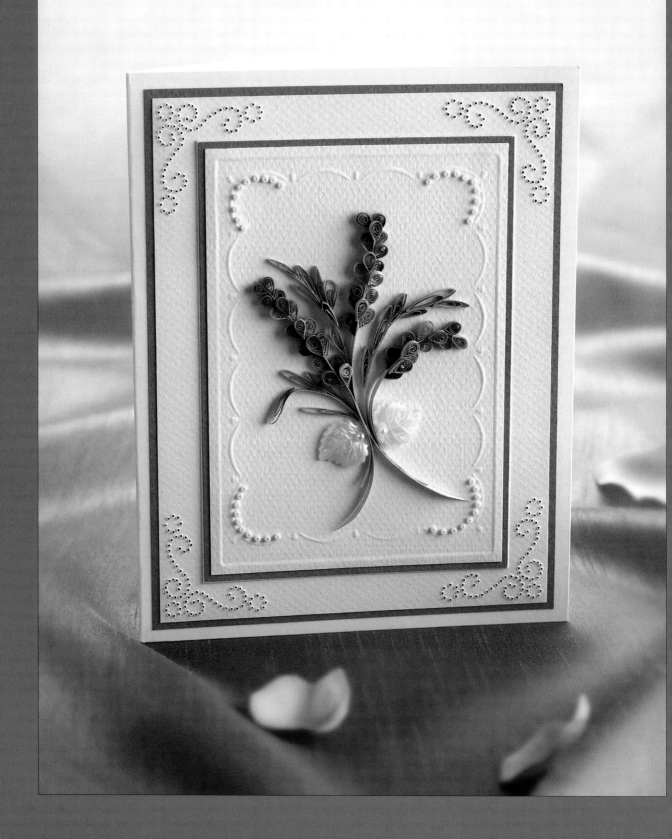

Sweet Lavender

Lavender is my favourite flower, and this quilled design makes a lovely card that someone special will want to keep. The petals, leaves and stems are made using simple quilling techniques. As well as quilling and paper piercing, the card features embossing and added beads and leaf beads.

1 Take the larger piece of ivory pastel paper and tape the pricking template to one corner using masking tape.

2 Place the paper and template on the pricking mat and pierce the corner design through the paper using the pricking tool.

3 Repeat for the other three corners. Mount the work with the pricked side uppermost on to violet pastel paper, using double-sided tape.

4 Trim a narrow border around the design using a craft knife and cutting mat as shown on page 10. Mount it on to the folded card blank using double-sided tape.

YOU WILL NEED

Cream card blank, 142 x 180mm (5⅝ x 7⅛in)

Two pieces of ivory pastel paper, 128 x 165mm (5 x 6½in) and 95 x 135mm (3¾ x 5⅜in)

Pricking template EF 8032

Masking tape

Embossing stencil 5815 S

Light box

Two sheets of violet pastel paper

Ivory seed beads

Two leaf beads

Two 2mm (1/12in) pearls

Embossing tool

Pricking tool and mat

Craft knife and cutting mat

Metal ruler

Double-sided tape

Quilling tool

Quilling papers, 2mm (1/12in) and 3mm (1/8in) in various shades of green and lavender

PVA glue with fine applicator

Tweezers

Cocktail stick

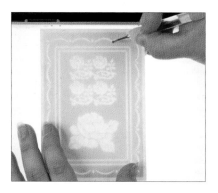

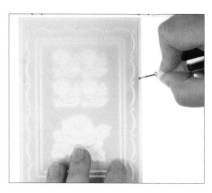

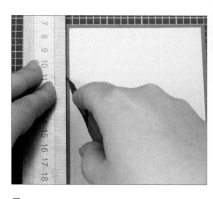

5 Tape the embossing stencil on top of the smaller piece of ivory pastel paper on the light box and emboss the scalloped border.

6 Run the embossing tool round the outer edge of the stencil. This will create a frame around the design.

7 Mount the piece on violet pastel paper using double-sided tape and trim to create a narrow border.

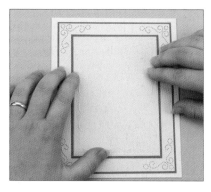

8 Mount this piece on the card blank using double-sided tape.

9 To make the petals, place one end of a lavender quilling paper strip into the top of the quilling tool.

10 Rotate the tool to wind up the paper strip.

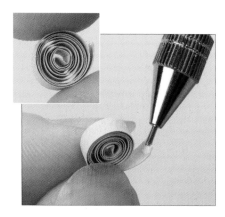

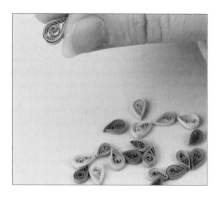

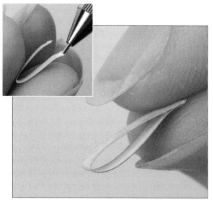

11 Remove the tool and let the coil bounce open slightly. Add a tiny drop of glue to the end to close the coil.

12 Form a teardrop from the coil by pinching one side. Make forty-five lavender teardrop-shaped petals; fifteen for each flower stem.

13 Form a leaf by making a small loop from a 2mm ($^1/_{12}$in) green strip and gluing the end to close it.

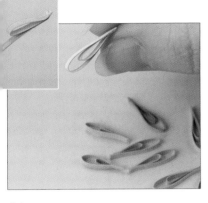

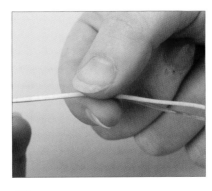

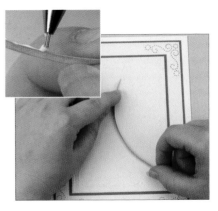

14 Glue a longer piece of the same strip to the first loop, bring the second strip round in a loop and glue to close. Make seventeen leaves in this way.

15 Glue and then pinch together two 3mm (¹/₈in) green quilling strips to make a double thickness stem.

16 Cut a piece 110mm (4³/₈in) long and glue the edge of the strip to attach it to the card. Form and attach five stems, using the finished card on page 14 as a guide.

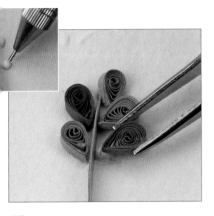

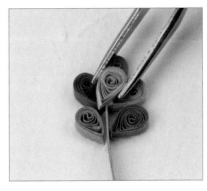

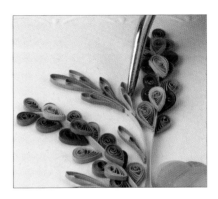

17 Place dots of glue where you want the petals to go, down both sides of the stems, and use tweezers to place the petals.

18 Place some petals on top of the stems as shown.

19 Glue on the leaves in the same way, using the finished card on page 14 as a guide.

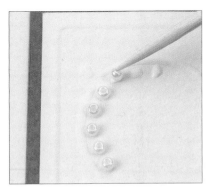

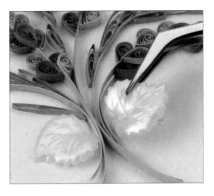

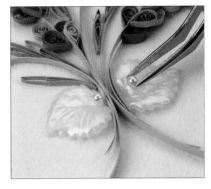

20 Glue ten ivory seed beads just inside each embossed corner using the method shown on page 13.

21 Glue on a plastic leaf bead either side of the stem.

22 Glue a pearl on each leaf bead to finish.

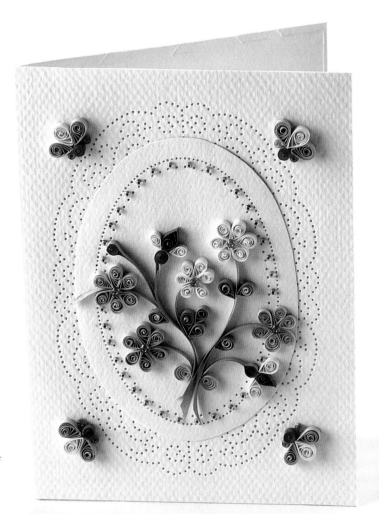

Quilled Posy

The pierced, lace-effect border from template Pro507 perfectly sets off this posy of quilled flowers.

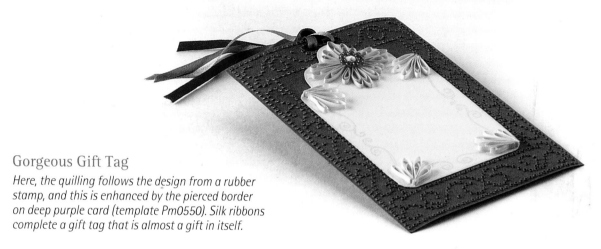

Gorgeous Gift Tag

Here, the quilling follows the design from a rubber stamp, and this is enhanced by the pierced border on deep purple card (template Pm0550). Silk ribbons complete a gift tag that is almost a gift in itself.

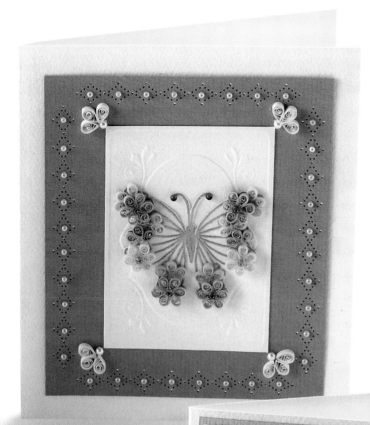

Golden Butterfly

The gold butterfly on this card was made using a rubber stamp and embossing powder and it is enhanced by quilled petals made from parchment. The embossing on the cream central panel is from template FS948, while the blue pricked frame is from template no. 4.050.338.

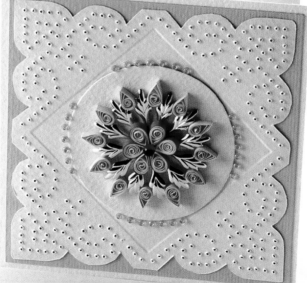

Peach Dream

The centrepiece of this card is a gold metal embellishment (no. 4.054.118). The teardrop petals slot in to create the effect of a flower.

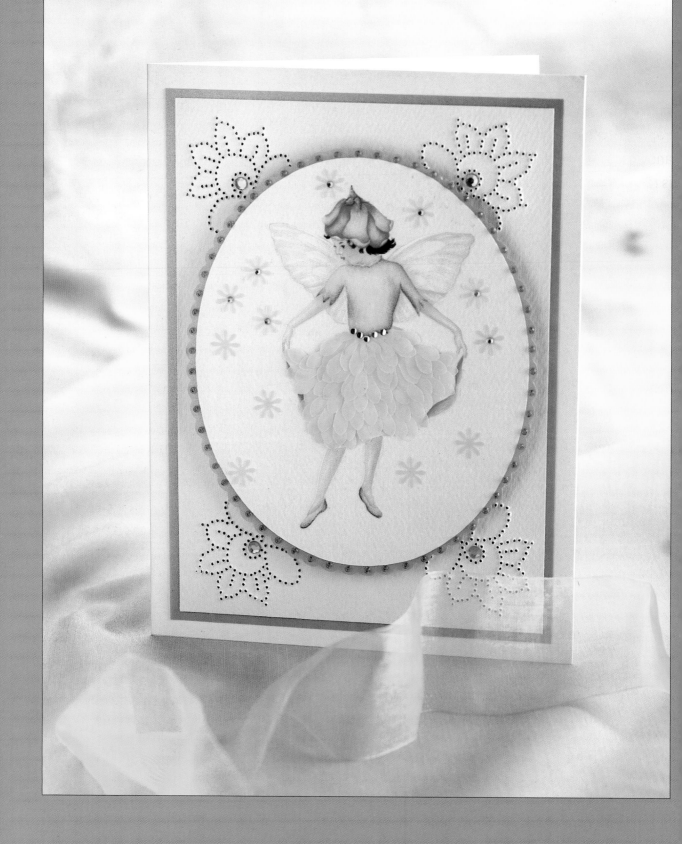

Fairy Princess

A rub-on transfer makes the perfect centrepiece for this fairy card. Daisy shapes punched from yellow vellum surround the fairy, and some are cut up to create her wonderful flowery skirt. Paper pierced flower patterns make a pretty frame and gems and beads add a sparkle to the fairytale scene. The central oval is raised from the main card to add another dimension.

The template for the oval.

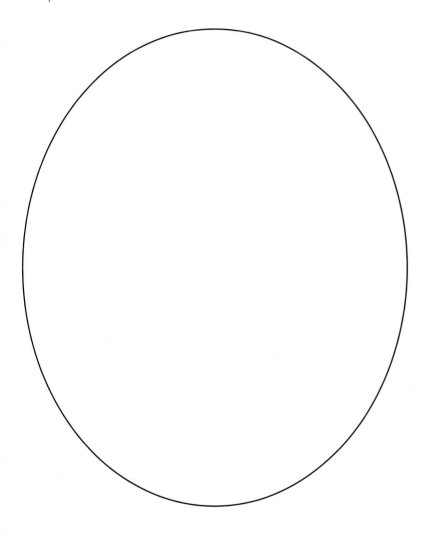

YOU WILL NEED

Cream card blank, 135 x 180mm (5³⁄₈ x 7¹⁄₈in)

Glistening green vellum

Two pieces of ivory pastel paper, 118 x 160mm (4⁵⁄₈ x 6¹⁄₄in)

Yellow vellum

Pricking template Pro540

Rub-on transfer TIP-691 and stick

Daisy punches, 10mm (³⁄₈in), 15mm (⁵⁄₈in) and 25mm (1in)

Four 4mm (³⁄₁₆in) topaz gems

Seven 2mm (¹⁄₁₂in) topaz gems

Five 2mm (¹⁄₁₂in) green gems

Gold seed beads

3D foam pads

Double-sided tape

Masking tape

Scalloped scissors

Fine scissors

PVA glue with fine applicator

Pricking tool and mat

Cocktail stick

Tweezers

Craft knife and cutting mat

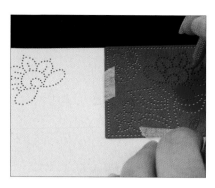

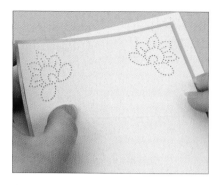

1 Attach the pricking template to a corner of one of the pieces of ivory pastel paper using masking tape.

2 On the pricking mat, pierce the flower and the two large petals. Repeat for the other three corners.

3 Mount the pierced piece on to green vellum using double-sided tape and trim, leaving a narrow border. Mount this on to the card blank.

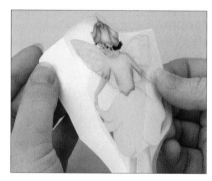

4 Transfer the oval template on to the second piece of ivory pastel paper and cut out the oval using fine scissors.

5 Mount the oval on to green vellum using double-sided tape and use scalloped scissors to cut a border round the oval.

6 Cut the rub-on transfer from the sheet and remove the paper backing.

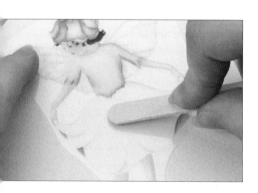

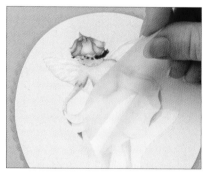

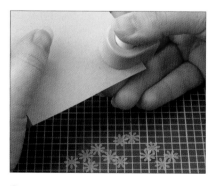

7 Place the design in the centre of the oval and rub firmly using the stick provided.

8 Carefully remove the plastic top sheet.

9 Use the smallest punch to punch twelve daisies from yellow vellum.

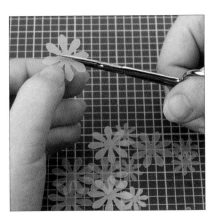

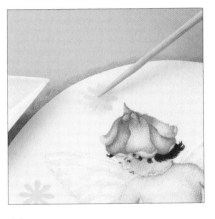

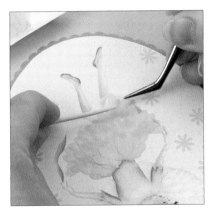

10 Punch a selection of medium and large daisies from yellow vellum and cut them into quarters.

11 Use PVA glue and a cocktail stick to glue the daisies around the fairy design, using the finished card on page 20 as a guide.

12 Glue the petals on from the top down to fill the fairy's skirt. Use a cocktail stick and tweezers to help you.

13 Attach 3D foam pads to the back of the oval and peel off the backing.

14 Attach the oval to the centre of the card blank.

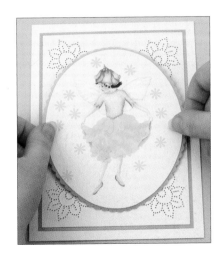

15 Stick on the beads and gems using the finished card on page 20 as a guide. The gold seed beads go within the scallops around the oval; the larger topaz gems go in the centres of the pricked flowers and the smaller ones in the centres of the daisies; the five green gems make a belt for the fairy.

Rose Posies

The rose rub-on transfers on this card are surrounded by beads, embossing and paper piercing designs (from template no. 4.050.350). Two shades of purple vellum are used to complement the transfers.

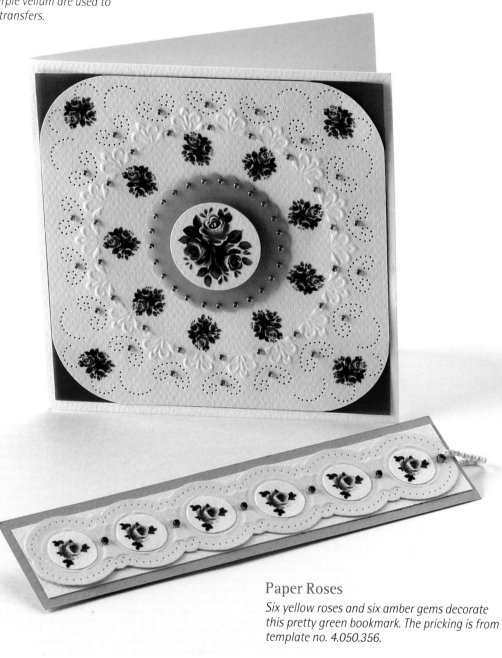

Paper Roses

Six yellow roses and six amber gems decorate this pretty green bookmark. The pricking is from template no. 4.050.356.

Violet Cameo

The central rub-on transfer is raised here to create the effect of a cameo. It is surrounded by smaller rub-on transfers and a Victorian piercing design from templates FR6401 and 3006.

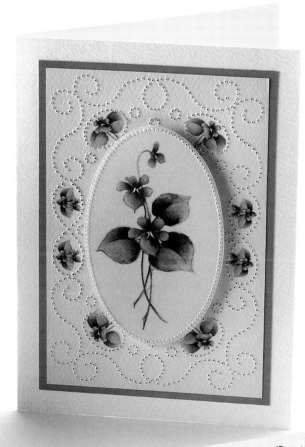

Flowers and Gems

Paper piercing from template no. 4.050.350 creates the perfect decoration around the violet rub-on transfers, beads and gems that adorn this card. The lines within the circle are from template no. 4.050.349.

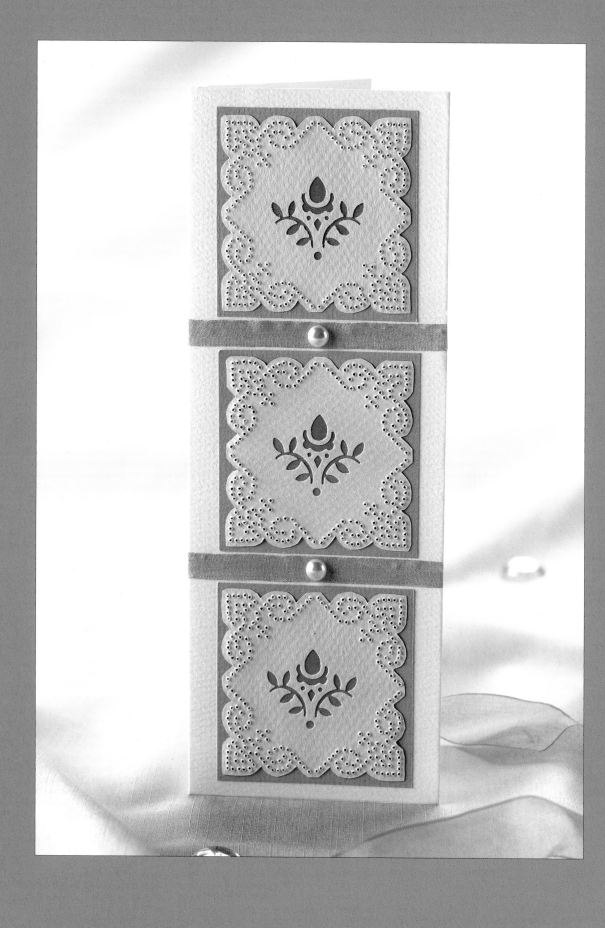

Rosebuds

Paper piercing creates a traditional setting for this contemporary rosebud design punched into three panels. Cool pastel colours, silk ribbon and flat-backed pearls complete a delicate and elegant looking card. All the items on pages 30–31 have been created using the same punch. Different styles can be achieved by punching in borders or on the corners, or by using different colours behind the punched rosebuds.

YOU WILL NEED

Folded ivory card blank, 70 x 200mm (2¾ x 7⅞in)

Three squares of lilac pastel paper, 58 x 58mm (2¼ x 2¼in)

Ivory pastel paper, 9 x 9cm (3½ x 3½in)

Two squares of mint green pastel paper, 9 x 9cm (3½ x 3½in)

Lilac pearlescent paper

Mint green pearlescent paper

Mint green silk ribbon, 7mm (¼in)

Two 6mm (¼in) flat-backed pearls

Masking tape

Fine scissors

Pricking tool and mat

PVA glue with fine applicator

Rosebud punch

Pricking template 4.054.118

Pencil

Tweezers

Double-sided tape

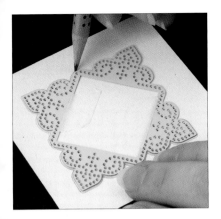

1 Using masking tape, stick the pricking template to a piece of ivory pastel paper. Pierce the design using a pricking tool and mat.

2 Draw round the outside of the template with a pencil.

3 Cut round the pencil line with fine scissors.

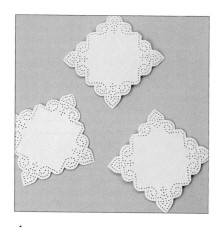

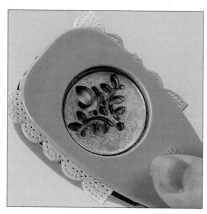

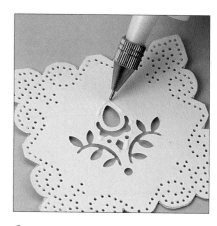

4 Repeat steps 1–3 twice more on mint green pastel paper.

5 Using the punch upside down, punch a rosebud in the middle of each pricked square.

6 Apply PVA glue to the back (the smooth side) of the ivory panel, around the rosebud design.

Tip
Use PVA glue instead of double-sided tape to stick down pricked pieces as it dries clear and will not show through the holes.

7 Cut a piece of lilac pearlescent paper large enough to cover the flower part of the rosebud design and use tweezers to secure it over the flower holes.

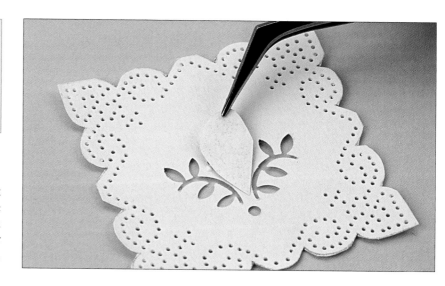

8 Cover the leaf-shaped holes in the same way with mint green pearlescent paper.

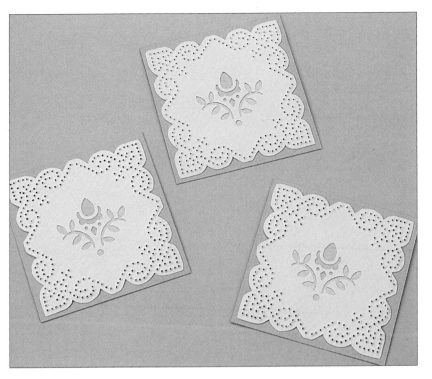

9 Repeat steps 6, 7 and 8 for the other two panels. Stick each panel on to a square of lilac pastel paper using PVA glue.

10 Stick the three panels on to the card blank using double-sided tape.

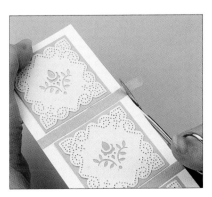

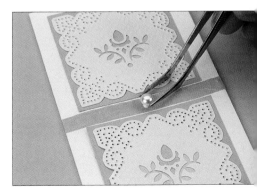

11 Stick double-sided tape to the back of the silk ribbon, peel off the backing and stick the ribbon between the panels on the card.

12 Trim the ends of the ribbon neatly at the edge of the card.

13 Glue a flat-backed pearl to the centre of each piece of ribbon.

Pearls and Rosebuds

The rosebud punch makes a striking design when used sideways on, and flat-backed pearls add a touch of elegance to the natural-looking colours.

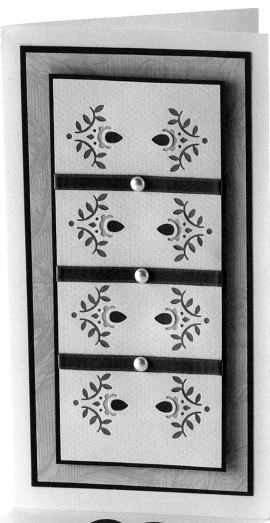

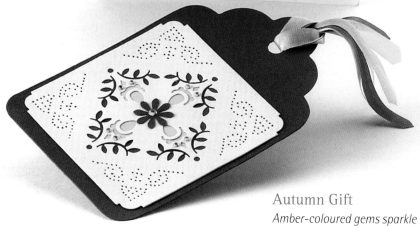

Autumn Gift

Amber-coloured gems sparkle in this elegant gift tag in the colours of autumn. The pricking is from template no. 4.054.118.

Golden Roses

Lilac backing card works well with these golden rosebuds, and tiny gems set off the pierced central panel from template 10B 5A.

Rosebud Sparkle

This sumptuous card has been created using extra-fine glitter for the rosebuds and a tiny gold embellishment for the centre. The pricking is from template no. 4.050.332.

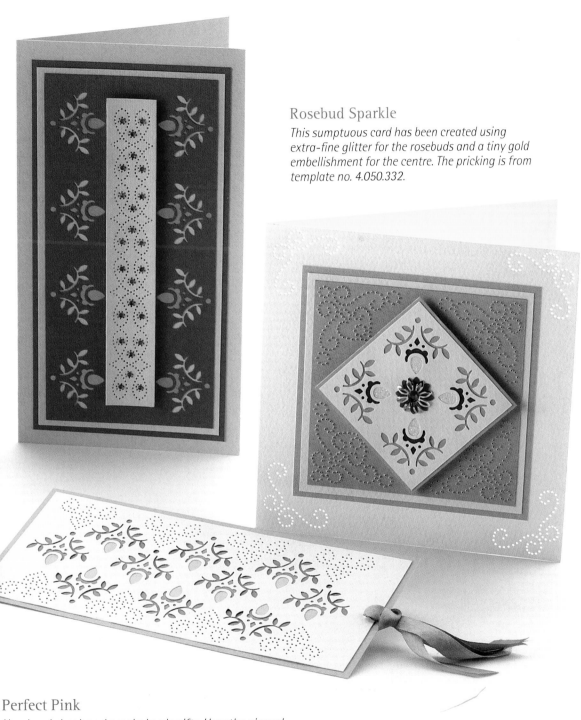

Perfect Pink

Handmade bookmarks make lovely gifts. Here the pierced design from template no. 4.054.118 perfectly complements the punched rosebuds.

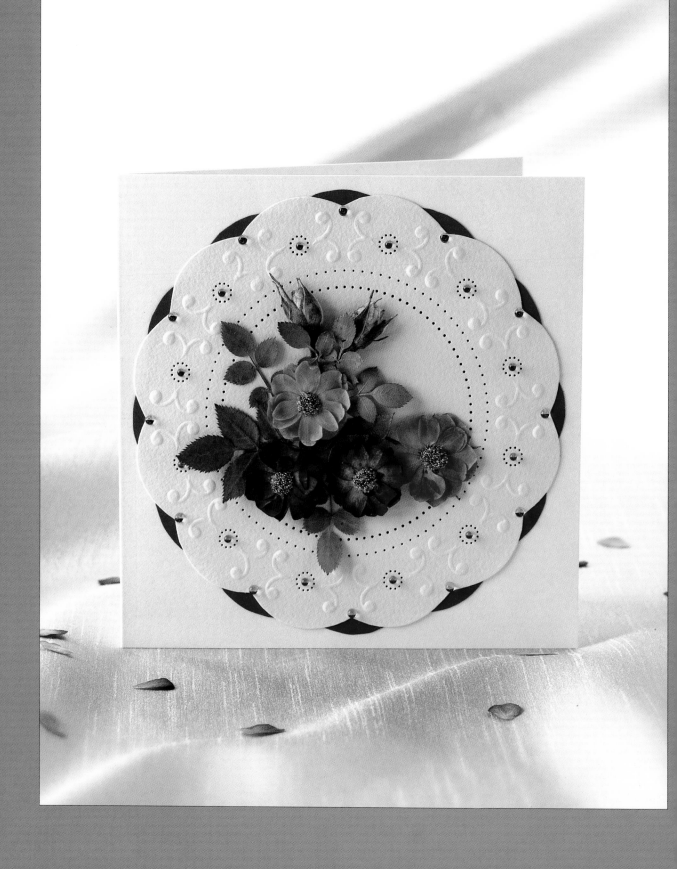

Pressed Roses

Pressed flowers can be a reminder of precious moments in time. They vary a lot in colour but this helps to make each card you make with them unique. Use natural colours for background papers to complement the flowers. Accent beads stuck on to the centres of these roses really add something special to the flowers. Leaves and rosebuds have also been used to create a beautiful spray. A multipurpose pricking and embossing stencil has been used for this card and its edges have been used to create the scalloped central panel and the burgundy backing panel. Gems add a finishing sparkle.

YOU WILL NEED

Square ivory card blank,
144 x 144mm (5¾ x 5¾in)

Ivory pastel paper

Burgundy paper

Assorted pressed roses, buds and leaves

3D foam pads

Double-sided tape

Masking tape

PVA glue with fine applicator

Embossing and pricking stencil 500 000/5104

Twelve lilac 3mm (¹/₈in) gems

Twelve pink 2.5mm (¹/₈in) gems

Tortoiseshell accent beads

Fine scissors

Embossing tool

Pricking tool and mat

Light box

Pencil

Tweezers

1 Tape the stencil to a piece of ivory pastel paper and tape this to a light box. Using the embossing tool and working from the back, emboss the border scrolls round the edge of the stencil.

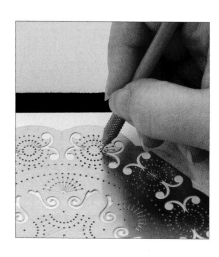

2 Turn the card over so the stencil is on top. Using a pricking tool and mat, pierce the small circles between the embossed scrolls. Also pierce the two central semi-circles.

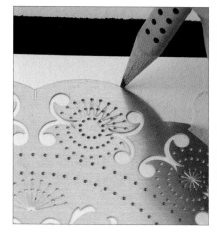

3 Draw around the scalloped edge of the stencil with a pencil.

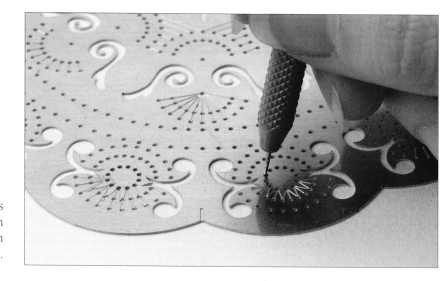

4 Flip the stencil over so that it covers the bottom of the paper, stick it down and emboss and prick the design again so that you have a circular pattern.

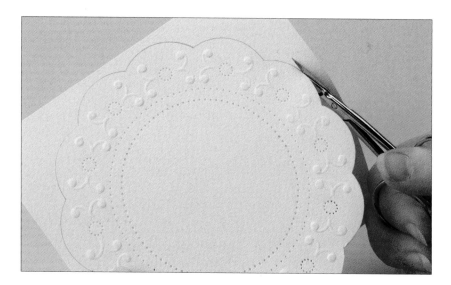

5 Draw round the edge of the stencil as before, then remove it and cut out the shape using fine scissors.

6 Stick the stencil to the burgundy paper and draw round it in two stages as before to make a scalloped circle.

7 Cut out the burgundy scalloped circle and mount it on to the card blank using double-sided tape.

8 Mount the pricked and embossed piece on top of the burgundy scalloped circle so that the scallops show between each other. Use double-sided tape in the middle and PVA glue around the edge.

9 Choose four rose heads and put a large dab of glue in each centre.

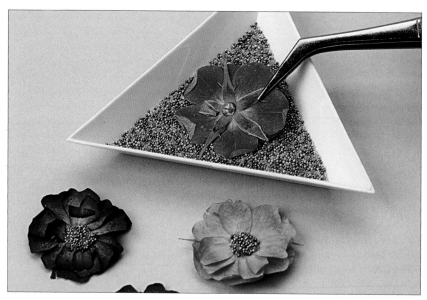

10 Place the tiny accent beads in a dish. Use tweezers to dip each rose head in the beads so that the glued area is coated in them. Leave them to dry.

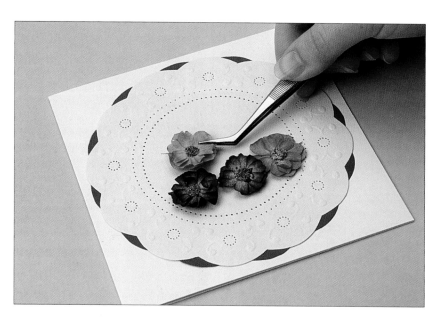

11 Referring to the picture of the finished card on page 32, stick on one rose with PVA glue and three with 3D foam pads. Use tweezers to help you.

12 Choose seven sprays of rose leaves and apply glue to the base of each stem.

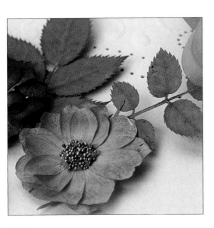

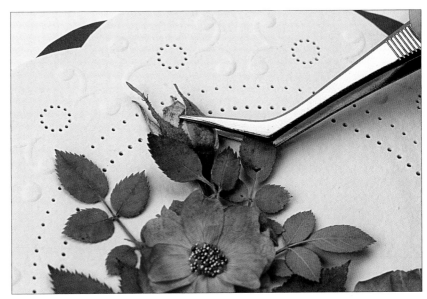

13 Glue the sprays of leaves around the roses by poking the glued stems underneath the flower heads.

14 Glue two rosebuds at the top of the design, poking the stems under the leaf sprays.

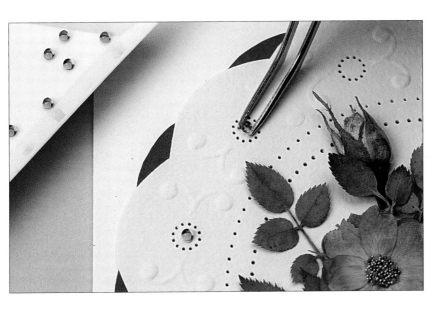

15 Glue a 2.5mm ($^1/_8$in) pink gem inside each pricked circle.

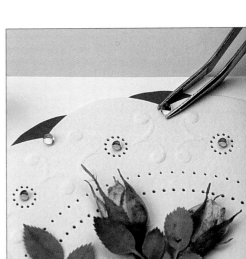

16 Glue a 3mm ($^1/_8$in) lilac gem at the inner point of each scallop.

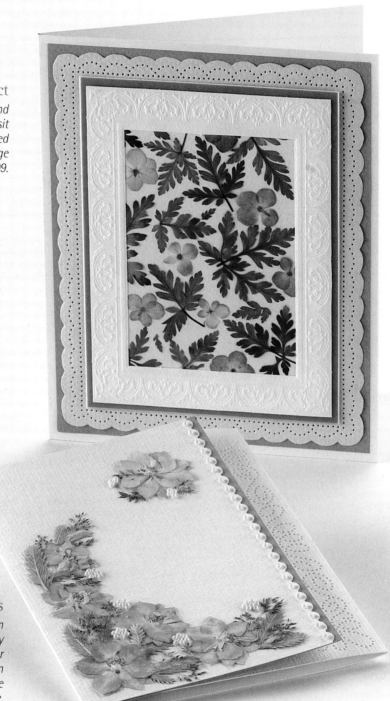

Naturally Perfect

Herb Robert leaves and hydrangea flowers sit beautifully inside an embossed frame and a pierced lacy edge from template Pro509.

Pink and Pearls

The swirling pierced pattern from template PM028 perfectly complements the pink larkspur and silvery leaves on the main card. Tiny pearl beads complete a very pretty picture.

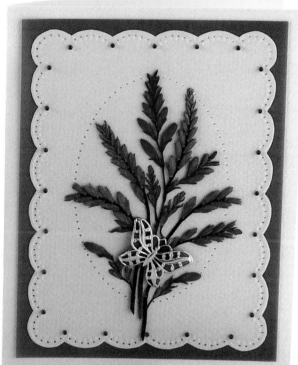

Golden Butterfly

The elegant spikes of montbretia have retained their bright colour when pressed. The little butterfly embellishment gathers them together. The pricking is from an embossing stencil, LJ822, which can be pricked as well as embossed.

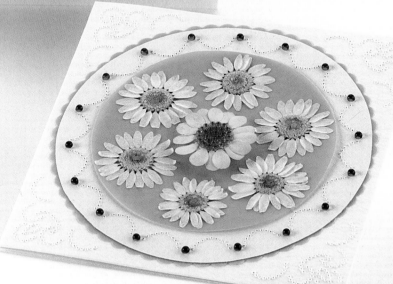

White Splendour

The yellow chrysanthemum with the beaded centre is surrounded by white splendour anemones mounted on green parchment with swags of piercing. The pierced corner design on the main card (template no. 4.050.35) completes a beautiful, fresh-looking card. The circle is from template Pro561.

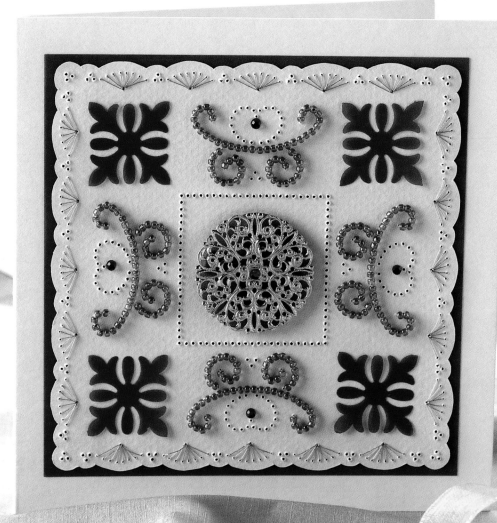

Embroidered Creation

It is always worth every minute when you are making a special card for a treasured friend. In this spectacular square design, embroidery in gold thread sets off the large brass embellishment in the centre and purple beads and punched vellum shapes complete a plush and precious look. It will not take you long to learn how to embroider the panel edges or to sew beads on to the pierced scrolls, but the effect is striking.

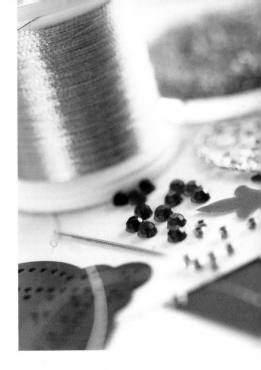

YOU WILL NEED

Ivory card blank 144 x 144mm (5¾ x 5¾in)

Two sheets of purple vellum

Gold thread and needle

Pricking template Pro502

Ivory pastel paper, 160 x 160mm (6¼ x 6¼in)

Purple seed beads

Five 3mm (⅛in) faceted gems

Metal embellishment, 35mm (1⅜in) in diameter

Decorative square punch, 25mm (1in)

Pricking tool and mat

PVA glue with fine applicator

Masking tape

Double-sided tape

Pencil and ruler

Fine scissors

Low-tack sticky tape

Craft knife and cutting mat

Tweezers

3D foam pads

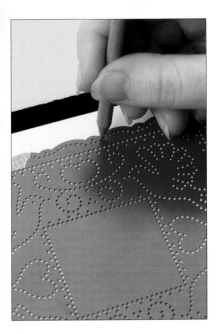

1 Using masking tape, fix the pricking template on to a piece of ivory pastel paper. Pierce the scalloped outer border design using a pricking tool and mat.

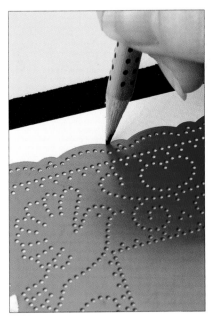

2 Draw round the edge of the template with a pencil.

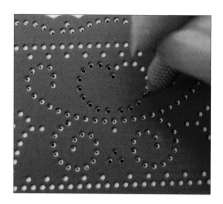
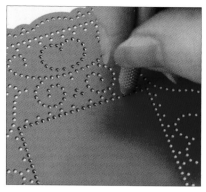

3 Leaving the template in place, pierce the large scroll lightly and the heart design more deeply at the top and bottom of the design.

4 Pierce deeply around the inner square of the design.

5 Remove the template from the paper and turn it ninety degrees. Replace the template on the paper, using the pencilled edge as a guide. Pierce the scroll and heart designs on either side of the design again.

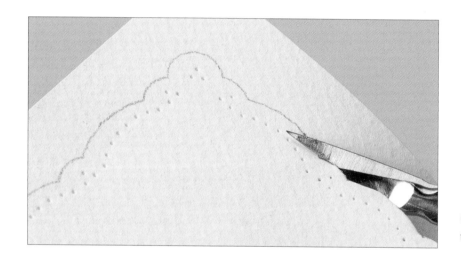

6 Remove the template and cut round the pencil line using fine scissors.

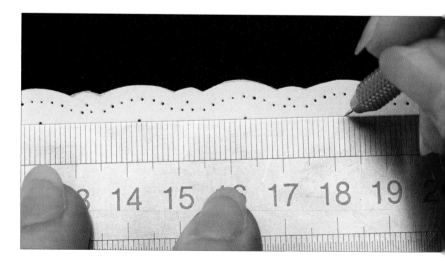

7 On a pricking mat, pierce a hole approximately 5mm (¼in) down from the centre of each scallop. Use a ruler to help you.

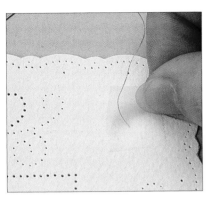

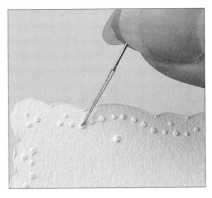

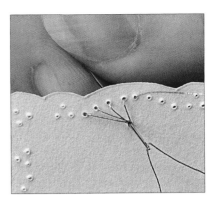

8 Thread a needle with gold thread. At the back of the pricked piece, stick the end of the thread to the paper using low-tack sticky tape.

9 Take the needle through to the front of the piece, coming out of hole 1 of a scallop shape.

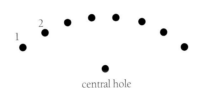

central hole

10 Go down through the central hole and come up in hole 2. Continue, going down the central hole and up through each of the scallop holes in turn. Repeat for all the scallop shapes.

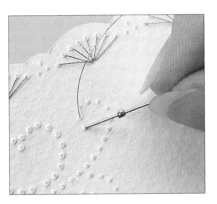

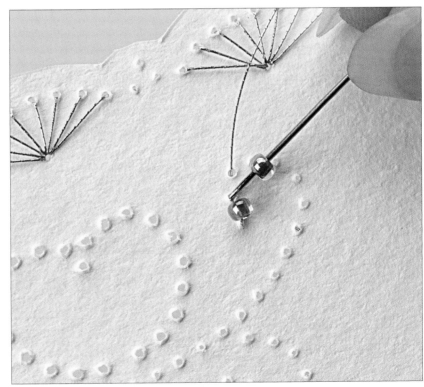

11 Start to stitch the purple seed beads on to the scrolls using back stitch. Come up through hole 2, thread on a bead and go down hole 1.

12 Come up through hole 3, thread on a bead and go down hole 2. Continue in this way until all the scroll is decorated with beads.

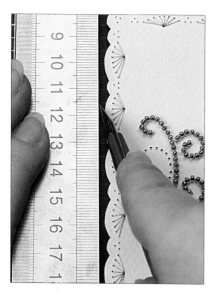

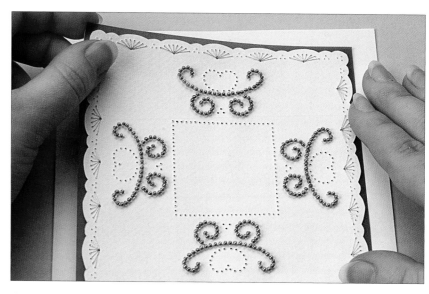

13 Mount the stitched card on to purple vellum using double-sided tape and trim the vellum, leaving a narrow border as shown.

14 Mount the stitched card on to the front of the ivory card blank using double-sided tape.

15 Punch four square motifs from purple vellum.

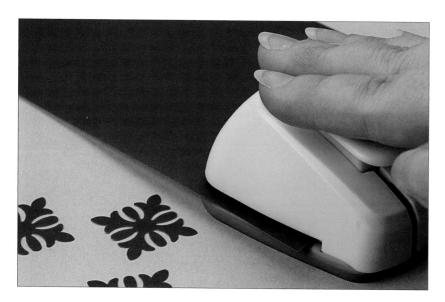

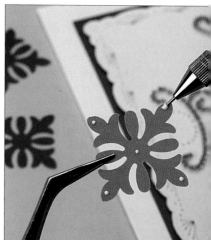

16 Place tiny dots of PVA glue on the back of the vellum punched pieces and use tweezers to stick them in each corner of the main card.

17 Draw round the brass embellishment on a piece of purple vellum. Cut out the circle.

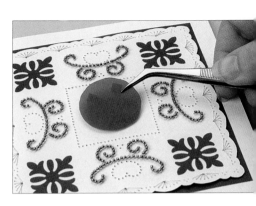

18 Stick the vellum in the centre of the pierced square using 3D foam pads.

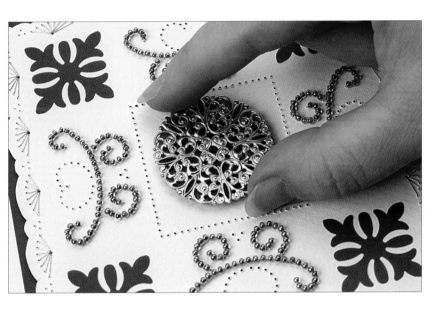

19 Use PVA glue to stick the brass embellishment on top of the vellum circle.

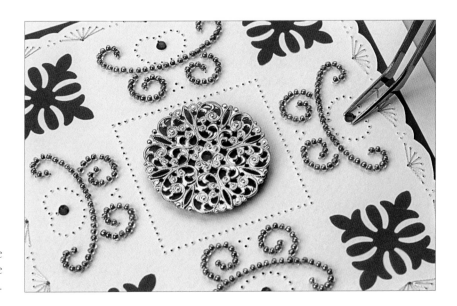

20 Glue a gem in the centre of the embellishment and also in the centre of each pierced heart.

Love Token

Pink embroidery frames this pink and cream card. The central gold heart appears to be suspended from a string of tiny pearls, and piercing completes the delicate decoration. The corner piercing is from template EF8015 and the circle is from template Pro0536.

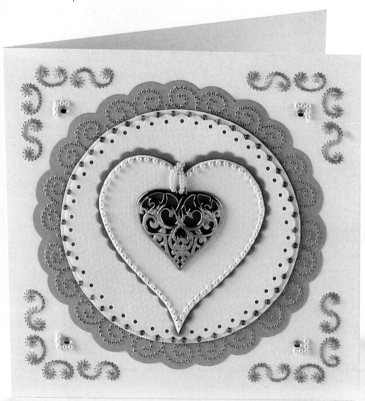

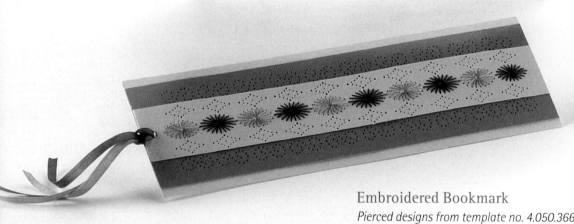

Embroidered Bookmark

Pierced designs from template no. 4.050.366 combined with simple embroidery and silk ribbons make a subtle bookmark that will be a lovely reminder of the giver.

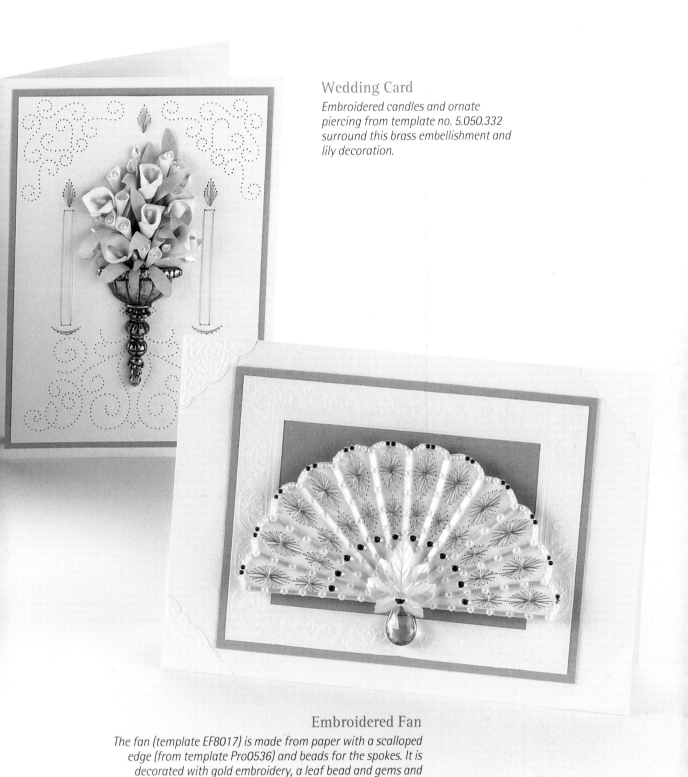

Wedding Card

Embroidered candles and ornate piercing from template no. 5.050.332 surround this brass embellishment and lily decoration.

Embroidered Fan

The fan (template EF8017) is made from paper with a scalloped edge (from template Pro0536) and beads for the spokes. It is decorated with gold embroidery, a leaf bead and gems and surrounded by an embossed frame and corners.

Index

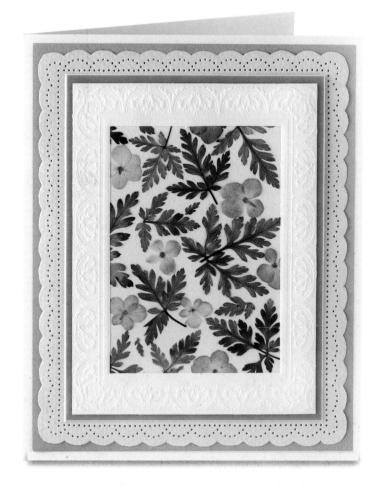